THE APERTURE HISTORY OF PHOTOGRAPHY SERIES

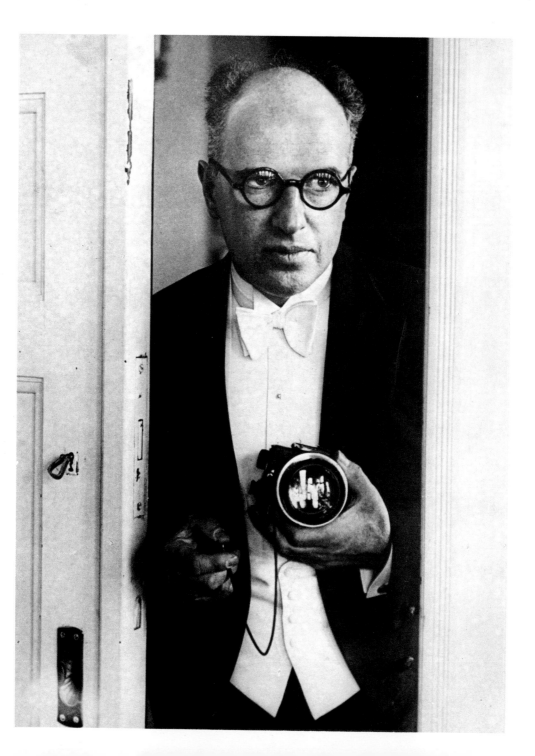

Erich Salomon

APERTURE

The History of Photography Series is produced by
Aperture, Inc., under the artistic direction of Robert
Delpire. Erich Salomon is the tenth book
in the Series.

Aperture, Inc., publishes a periodical, portfolios and
books to communicate with serious photographers and
creative people everywhere. A complete catalogue will
be mailed upon request. Address: Elm Street, Millerton,
New York 12546

Library of Congress Catalogue Card No.: 77-80021

ISBN: 0-89381-023-1

Manufactured in the United States of America.

In 1928, the popular German pictorial magazine *Berliner Illustrirte Zeitung* began to carry some remarkably candid photographs of world leaders. One picture, taken at an important summit conference in Lugano, Switzerland, showed key ministers from six of the globe's most powerful nations huddled around a small tea table in an alpine hotel. While the other ministers hunched forward to listen, the usually reserved British Foreign Secretary, Sir Austen Chamberlain, was caught with eyes glaring wildly and a cigar poised in his fingertips as he passionately expounded a point. In other photographs, delegates to the League of Nations in Geneva—who usually appeared in the press neatly gathered around the conference table with stiff, frozen expressions—became suddenly human as they joked, yawned, dozed, slouched, and chatted casually over lunch. Such revealing shots of politicians and other famous people are still rare; a half-century ago, they were revolutionary.

The man responsible for this minor revolution had accomplished the feat by having the insight to use a camera almost universally shunned by photographers and the temerity to venture into sanctuaries where few other photographers had dared to go. But he was neither a wily veteran of the press nor an imprudent gate-crashing young-

ster. Instead, he was an unassuming man named Erich Salomon, who at age forty-two was balding, bespectacled, a bit paunchy, and always very respectably attired. Until a year before, he had neither taken a photograph more serious than a snapshot, nor used a camera more complex than his wife's Brownie. He had become a photographer almost by accident, but he soon found himself riding on the crest of a wave that would change the very nature of photographic reporting.

Erich Salomon's pictures quickly spread to publications throughout the world. In 1929, the London *Graphic* coined the phrase "candid camera" to describe his technique. In time, the press dubbed him the "Houdini of Photography," the "Master of Indiscretion," the "Invisible Cameraman." One paper went so far as to call him "Diogenes with a Camera." But the designation he was happiest with was "Historian with a Camera," and the term he invented to describe himself was *Bildjournalist*—which is still the German word for photojournalist.

Although he also often ventured into courtrooms and concert halls, and sometimes into the homes of the famous, Erich Salomon was first and foremost a photographer of political events. From the beginning, driven by sound journalistic instincts as well as a strong sense of history, he

staked out as his own special preserve the most important happenings of his time—the almost continual round of international conferences. Paris, Geneva, Berlin, Lugano, and the Hague were among the sites where statesmen gathered during the years between the two world wars. They vainly tried to solve the tangle of problems that had arisen out of the first struggle, striving to stem the tide of political and economic unrest that was propelling the West into a second conflict.

Before Salomon entered the arena, photographs of these events were nearly always stiff and posed, devoid of life. The underpaid news photographer, out to get a serviceable shot, usually returned with pictures of rigid diplomats trying to hold a pleasant expression in the midst of an explosive flash of powdered magnesium. More imaginative photographers, still under the influence of the pictorialists, tried to convey a more realistic image, capturing statesmen hard at work over their papers or gazing pensively into the distance. At best, the latter were clever contrivances that revealed only the assumed personas of men who were all too aware of the camera.

Salomon's pictures stood out in startling contrast. They were intimate, unposed views taken when the subjects least suspected it—and for the first time, they exposed the men behind the public masks. The equipment was partly responsible. Salomon had chosen a camera that allowed him to shoot indoors without a flash and to maintain a very low profile. But, as always, the eye behind the camera was far more important, and few photographers have since duplicated his perception. He showed little concern for formal beauty

and more for the beauty that comes from an action plucked at its ripest and most revealing point— what Cartier-Bresson following the path that Salomon had blazed would call "the decisive moment." As a result, only dress and setting appear dated in Salomon's photographs. His subjects are still alive, and fifty years later, we can still see the men who held the future in their palms as Salomon captured them: debonair gamblers coolly playing with the world's fate, they are almost as unaware of the stakes as they are of his camera.

Although he started late, Salomon's earlier life had left him well prepared for his photographic pursuits. He was born in 1886 into a prosperous German-Jewish family well assimilated into Berlin society. His father was a banker and a member of the stock exchange; his mother came from a line of prominent publishers. As a youth he had the time and money to explore a variety of possible careers. He first studied zoology, then switched to engineering before finally settling on law and taking his degree in 1913. With the outbreak of World War I, he was drafted into the Kaiser's army and soon thereafter was captured during the first Battle of the Marne. He spent the next four years in prisoner-of-war camps, where he served as an interpreter and acquired the fluency in French that was later to prove invaluable in gaining entry to conferences.

In the postwar years, the family fortune melted away in the inflationary storms that devastated the German economy, and Salomon, after a brief period spent working on the stock exchange, was forced to live by his wits. He was involved in two entrepreneurial ventures—first as a partner

in a piano factory and then as owner of an electric car and motorcycle rental service. Both enterprises failed, but an advertisement he ran offering to give free legal and financial advice to car-rental customers while chauffeuring them around the countryside attracted the attention of the Ullstein publishing house; and in 1925, they offered him a job in their promotion department.

Ullstein was then the largest and most successful publisher in Europe. The house produced books and daily newspapers as well as the monthly magazines *Die Dame, Uhu,* and *Querschnitt.* The flagship publication, however, was the *Berliner Illustrirte Zeitung*—a pictorial weekly with a circulation that would hit a record 2 million by 1930. Under the directorship of Kurt Szafranski, the periodical had been revitalized in the postwar years, giving much greater emphasis to photography, and its success had spurred a large number of imitators.

At Ullstein, Salomon was in charge of the magazines' billboard advertising. In 1927, after numerous lawsuits against farmers who refused to adhere to the terms of contracts for billboards on their property, he borrowed an unwieldy studio camera from the photography department to document some of the sites for court evidence. He was immediately fascinated by photography, and soon began shooting feature pictures for the Ullstein dailies while taking his family on Sunday outings in the country. He purchased the standard newsman's camera—a 13 x 18 cm Contessa Nettel—but, dissatisfied with its bulky size, he set out to find a smaller and handier instrument. His dealer introduced him to the Ermanox, a compact plate-loaded camera about the size of today's 35 mm SLRs.

By combining a very large lens with a small image size, the Ermanox had become the first camera suitable for taking pictures in poor lighting conditions. In the four years it had been on the market, a few photographers had used it to shoot inside theaters or on the streets at night. But most shied away from the Ermanox because it was tediously difficult to focus accurately and because the tiny 4½ x 6 cm plate required enlarging. For Salomon, however, these difficulties were minor compared to the instrument's potential—with it he could stalk his unsuspecting prey. He was an artist who had discovered his medium. And he continued to use an Ermanox until 1932, when he switched to a Leica.

After experimenting with and mastering the technique of shooting indoors by existing light, Salomon had no trouble convincing Szafranski to let him cover the headline-making trial of a police killer for *Berliner Illustrirte.* Any pictures taken in the courtroom, where photography was forbidden, would have been a major scoop for the paper, but the ones that Salomon returned with were extraordinary. They not only captured the atmosphere of the trial perfectly but also included sharp, dramatic close-ups of the defendant, his mother, the lawyers, and witnesses. Salomon had accomplished this by hiding his camera in a bowler hat, cutting a hole for the lens. On the last day, when a court attendant finally realized what he was doing and demanded his negatives, Salomon resorted to a trick he was to use time and time again. He handed over unexposed plates, acted re-

pentant, and left with the exposed ones still in his pocket. In 1928, only one year after he had become interested in photography, Salomon's career was launched.

He soon covered another sensational murder trial. This time, Salomon, a confirmed gadgeteer, concealed his Ermanox in an attaché case outfitted with an intricate set of levers to trigger the shutter. When these pictures were widely published throughout Europe, he left his staff position at Ullstein to become a full-time professional. That same year, he covered his first series of international conferences: the summit meeting in Lugano, a session of the League of Nations in Geneva, and the signing of the Kellogg-Briand disarmament pact in Paris, where he calmly walked in and took the seat of the absent Polish delegate. In his free time, he frequented diplomatic and social events in Berlin.

The next year, 1929, was almost equally productive. In addition to covering the first Hague conference, he managed to breach the cloistered seclusion of both the German cabinet and supreme court during private deliberations. On the first of many trips to England, he took a chilling shot of the justices of the High Court of Appeals preparing to pass the death sentence—a picture which remained unpublished for years when Salomon discovered that he had committed an offense punishable by three months' imprisonment under British law. By year's end, at the bidding of *Fortune,* he was in California. And while he was there, he was able to get a charming series of a sleepy Marlene Dietrich making a 4 A.M. transatlantic phone call to her daughter in Berlin. He also re-

corded the first intimate glimpse of life on William Randolph Hearst's fabled San Simeon estate. Even at this early stage in his career, Salomon's style was fully matured, and many of the pictures that he took during his first two years as a professional are among his most famous. The revealing candid portrait of people and events was already recognized as his hallmark throughout the world.

Salomon's first two years also saw the emergence of a number of other outstanding pioneer photojournalists. Some had been inspired by Salomon; others had brought their distinctive style into the pressroom. Like Salomon, they had been encouraged by the German pictorial weeklies—especially Ullstein's *Berliner Illustrirte* and its chief rival, the *Münchner Illustrierte Presse.* The Munich paper had started out as a provincial imitation of the *Berliner,* but by 1929, under the sensitive editorship of Stefan Lorant, it had outstripped its model in the imaginative and sophisticated use of photographic features. These magazines had long been on the lookout for good photographers. In the early and mid-twenties, they had featured action sports shots by Martin Munkacsi and poetic travel essays by André Kertész. But it was only during those two years, 1928 and 1929, that they finally developed an elite corps that included Salomon, Felix Man, Georg and Tim Gidal, Umbo, Alfred Eisenstaedt, and Kurt Hübschmann. All were dedicated and perceptive reporters with cameras, and together they created the incisive and realistic style that has become the foundation of modern photojournalism.

Of these pioneers, Erich Salomon, with his stratagems and clever subterfuges, was the one

who captured the public imagination. Fueled in part by his own fondness for relating his exploits, an entire folklore developed about the lengths to which he would go to get a picture. Hats and attaché cases were not the only means he used to conceal his camera. He took a close-up of President Hoover at a Washington banquet by using a floral arrangement on the table for camouflage. An arm sling got him the first photograph of the United States Supreme Court in session. And a set of hollowed-out mathematics texts allowed him to penetrate the gaming rooms of a Monte Carlo casino—a realm even more sacrosanct than the political meetings he covered.

Of course, Salomon's ruses did not always work. Trying to infiltrate a gathering of Scottish nobles, he arrived with his camera embedded in a bagpipe, but was immediately ejected because he was wearing the kilt of a rival clan. At one Hague conference, he tried to get a shot of top leaders meeting on a fourth-floor balcony by outfitting himself as a painter and hiring a sixty-foot extension ladder and a crew of six, but the commotion he created caused the delegates to flee—with the British representative loudly complaining, "It just isn't cricket to attack ministers from fire escapes."

On a less flamboyant level, he was also a master at finding the vantage point in a nearby building overlooking a chancellery garden or the open window of an embassy. But most often, Salomon relied on his own natural camouflage to get him past police cordons and security lines into the heart of the action. Middle-aged, of medium height and somewhat bland in appearance, he carried himself with an easy dignity and a secure sense of propriety. There was little to distinguish him from any number of political functionaries. He always dressed correctly: in a dinner jacket or white tie and tails for banquets and receptions; in a conservatively tailored suit most of the rest of the time. Often he would hire a limousine and arrive in the manner of a minor dignitary.

Salomon also developed an almost perfect sense of timing in outwitting and outmaneuvering anyone who would try to stop him. "If you stand before the doors of a meeting room and ask the man in charge to let you in," he wrote, "it is not hard for that man to tell you all the reasons he can't let you in. If, however, before the meeting begins you are already in the room, the man in charge has to ask you to leave that room—this requires a far greater psychological effort on his part." Other times, he followed another rule—arriving exactly one hour late, when he knew that the doorkeepers, weary from the rush of earlier arrivals, would be more likely to be off guard. On occasion, he would wait until the arrival of a prominent person and simply tag along as if he were a member of that person's entourage.

Because of his background and age, Salomon emitted an aura of worldly sophistication. He was fluent in several languages, knowledgeable about political affairs, and when it was important to have a title, he could legitimately be called "Doctor"—as could any other graduate of a German law school. He easily won a large number of friends in political and diplomatic circles, and many were more than willing to help him. "After a time," he noted, "I found that there was scarcely a big international conference or important gather-

ing at which I had not at least one friend at court. And a trusted accomplice is the first invaluable asset for this work."

Whether or not aid was required, Salomon quickly discovered that once he was inside a conference room, banquet hall, or even a parliamentary assembly there was general acceptance of his presence by people who were basically genteel and unwilling to make a fuss. Thus he rarely resorted to his hidden-camera tricks, because, even though the Ermanox had advanced optics for the times, it was still usually necessary to make exposures of a quarter-second or longer, making a tripod almost mandatory. But, although his camera was blatantly mounted on a tripod and everyone knew he was taking pictures, Salomon succeeded in not letting his subjects know when he was shooting. He did everything possible to make himself and his camera melt into the background. He usually stood away from the tripod, with the end of a long cable release tucked in his palm. To avoid making a disturbing click, he frequently put a noiseless Compur shutter on the front of the lens. And although he had to change plates after each shot, no one ever seemed to notice when he did. Most of his subjects were truly amazed when they saw the pictures he had taken of them.

Today, considering how long his exposures were, it is surprising that Salomon got so many shots without any blurred figure motion at all. But again, he was successful because he was a master of timing. He was able to trigger the shutter just at the moment when there is an almost imperceptible pause in motion—capturing, for example, the instant in a conversation when the person speaking hesitates, holding his expression and gesture, while the listeners remain attentively immobile. Despite technical limitations, he was, as a rule, able to capture the quintessential moment.

Because of his dogged persistence, unobtrusive manner, and dramatic results, Salomon soon found fewer and fewer barriers to his presence in realms where all other photographers were excluded. Indeed, many statesmen began to develop a good-humored acceptance of his ubiquity. In the early 1930s, the German cabinet was preparing for a secret summit meeting on a small boat with members of Britain's Labour government. When the Prussian Prime Minister, Dr. Otto Braun, was asked if Salomon should be allowed on board, he reportedly smiled, shrugged his shoulders and said, "Surely, it's inevitable. Nowadays, you can hold a conference without ministers, but not without Dr. Salomon." Other politicians began to pay tongue-in-cheek tribute to the popularity of Salomon's photographs and to the widespread publicity the candid shots gave to them and to their work. At the opening of another international gathering, the French Foreign Minister, Aristide Briand, amused his fellow delegates by looking around the room and exclaiming, "Where is Dr. Salomon? We can't start without him. The people won't think this conference is important at all!"

Actually, many world statesmen recognized almost from the beginning that the importance of Salomon's pictures was more than transitory. In November 1931, *Time* reported, "President Hoover might never have allowed Dr. Erich 'Candid Camera' Salomon in the White House if

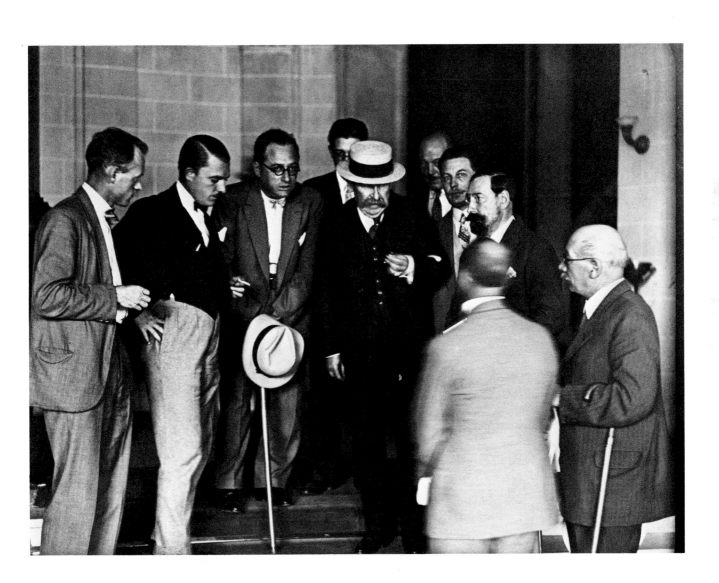

Premier Laval of France had not politely insisted. Like Benito Mussolini, Ramsay MacDonald, and Chancellor Brüning, Pierre Laval has become convinced that Dr. Salomon's spontaneous snapshots are historic documents to be preserved for posterity. . . ." It was a view that Salomon himself increasingly began to subscribe to.

By 1931, Salomon had reached the apogee of his career. To celebrate his forty-fifth birthday and the publication of his book, *Famous Contemporaries in Unguarded Moments*, he hosted a party for four hundred leading members of Berlin society at the elegant Hotel Kaiserhof, and he both astonished and amused his guests with a lantern slide show of candid shots he had taken of them on earlier occasions. But Salomon's celebrity in his homeland was short-lived. Only a year later, he returned from a second trip to America to find Hitler headquartered in the Kaiserhof and the Weimar Republic in its death throes. Although he still had time to get some telling pictures of Nazi shenanigans in the Reichstag, Salomon, like many others, was soon making preparations to leave.

Unlike most of his colleagues on the German weeklies who went to the United States and England, Salomon decided to settle in Holland, which was his wife's native country. Based in the Hague, he still had a ringside seat for Continental political contests and covered many key events. He also continued to travel. Britain especially fascinated him, and he made frequent visits to photograph government and opposition leaders and members of the royal family—although he failed in his repeated attempts to breach the ramparts that the British sense of propriety had erected around Buckingham Palace and the Houses of Parliament. During this period, he also began to take more and more pictures in concert halls, and in the end, he managed to get action shots of most of the great conductors of this century—usually by taking a seat with the orchestra.

In the late thirties, he began to concentrate on Dutch political and social life. He was invited to come to America by *Life,* one of the new pictorial magazines that had just begun to take root and had picked up many of his photographs. He considered emigrating, but he kept putting it off. Soon it was too late to leave. In May 1940, the Nazi *Blitzkrieg* swallowed the Low Countries in four days. The candid photographer who had been the toast of Berlin society only a few years before was recognized by his fellow countrymen only as "the Jew Salomon" and was forced to wear a yellow star. In 1943, the Nuremberg Laws, the implement for the "final solution," having been extended to German-occupied nations, Salomon and his family went into hiding. They were betrayed by a meter reader who noted an increase in gas consumption. According to Red Cross records, Erich Salomon died at Auschwitz in July 1944, a month after the Allies landed in Normandy.

Salomon's career as a photojournalist was brief—lasting barely more than a decade. But during it, he had truly been a historian with a camera, documenting one of the pivotal eras in modern history. He forged a style that inspired many photographers now more famous than he is, but he has never been surpassed as the master of the public person in private moments.

Peter Hunter (Salomon)

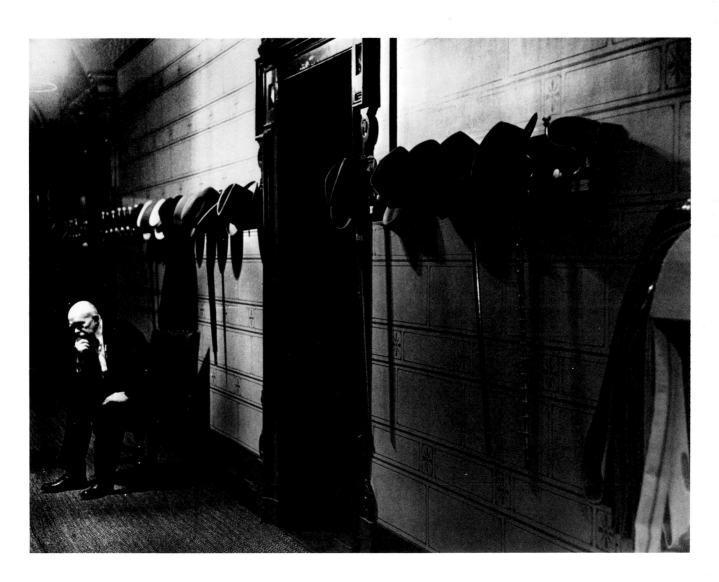

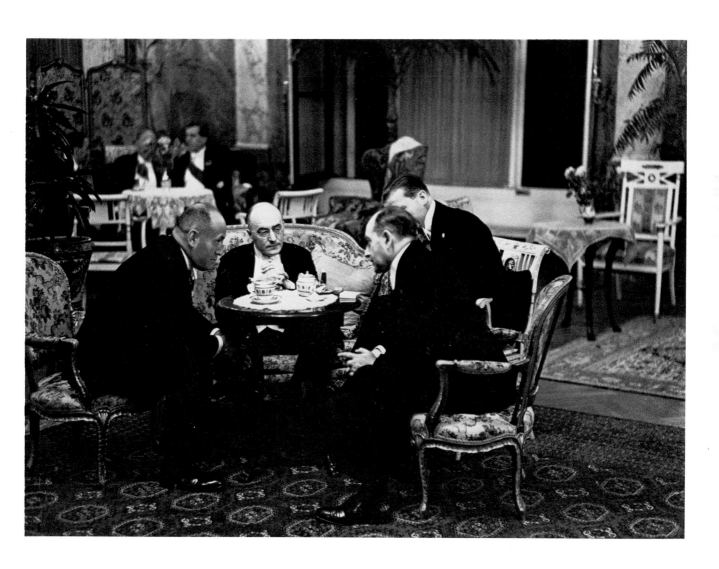

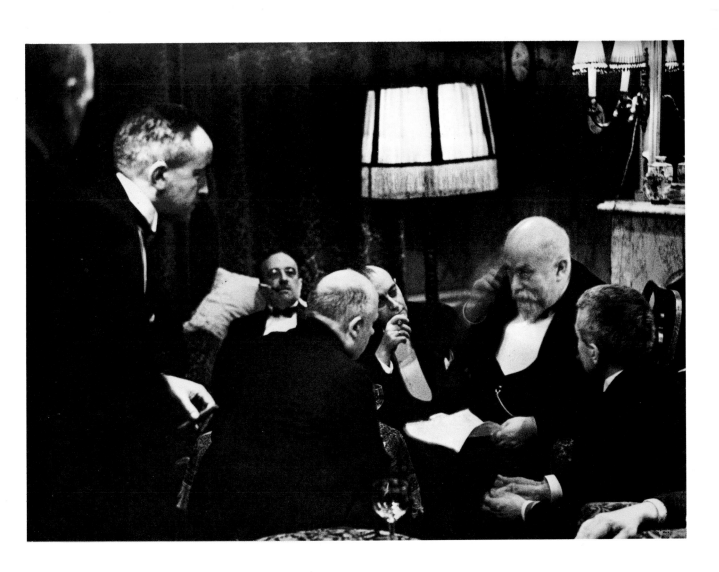

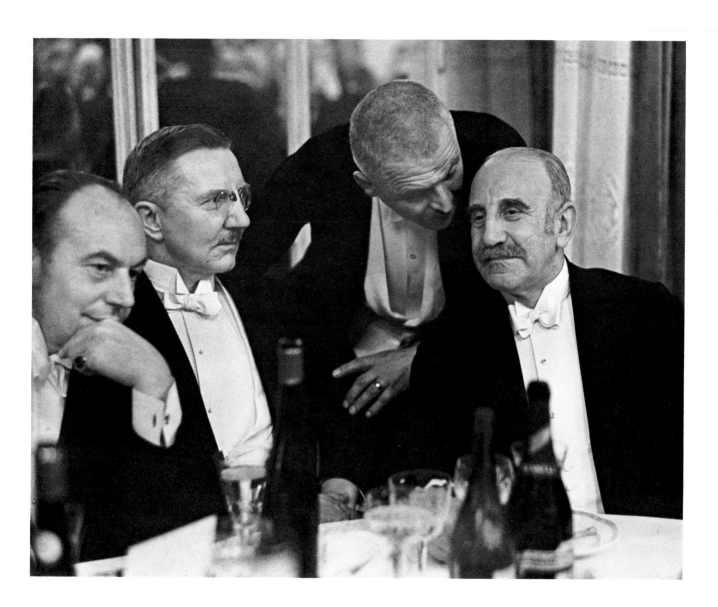

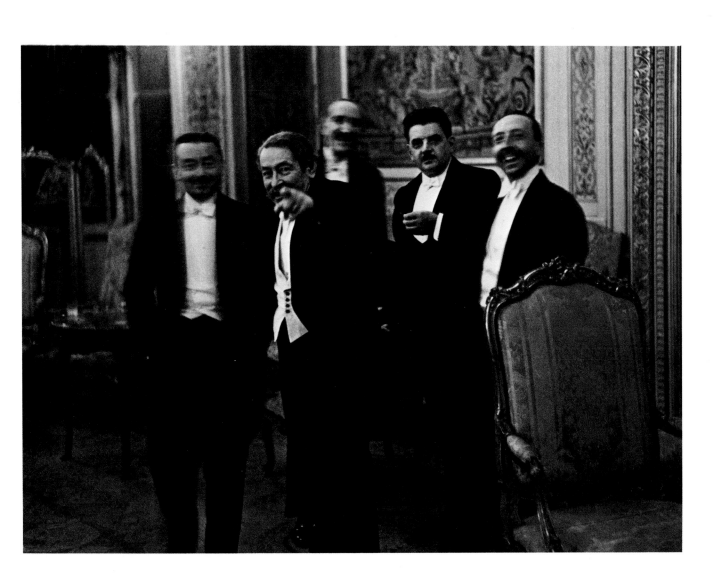

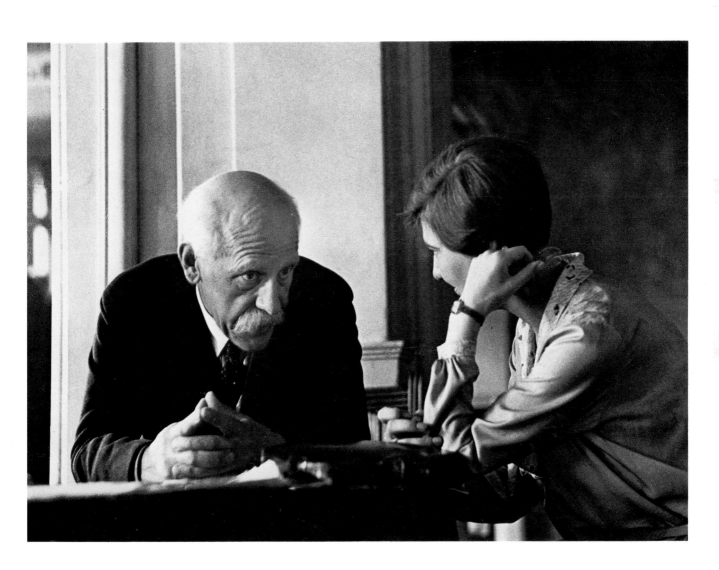

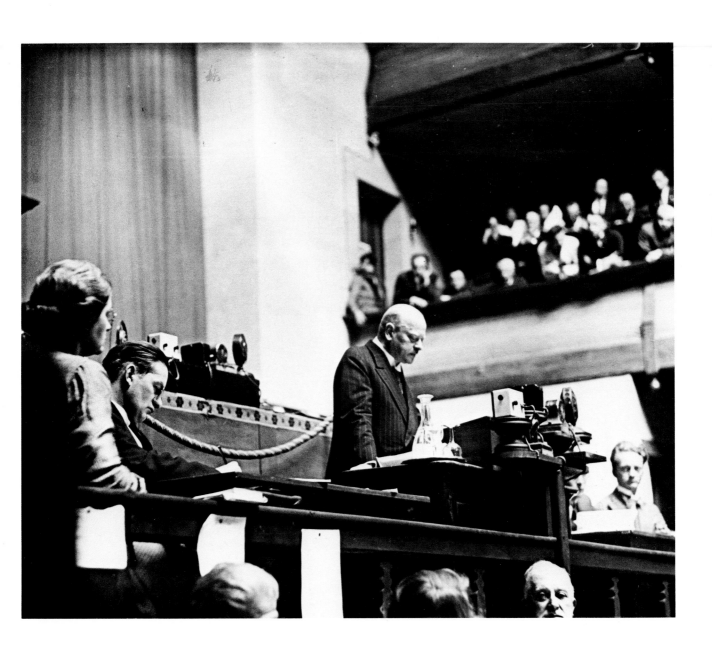

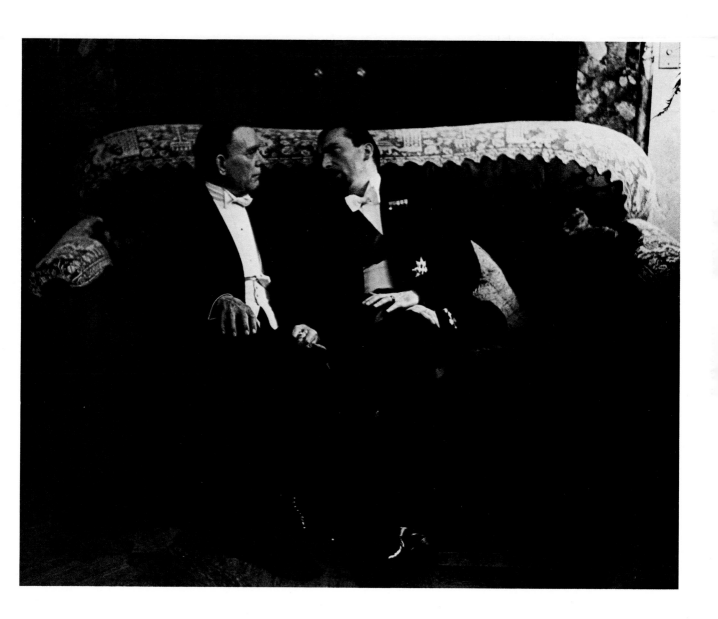

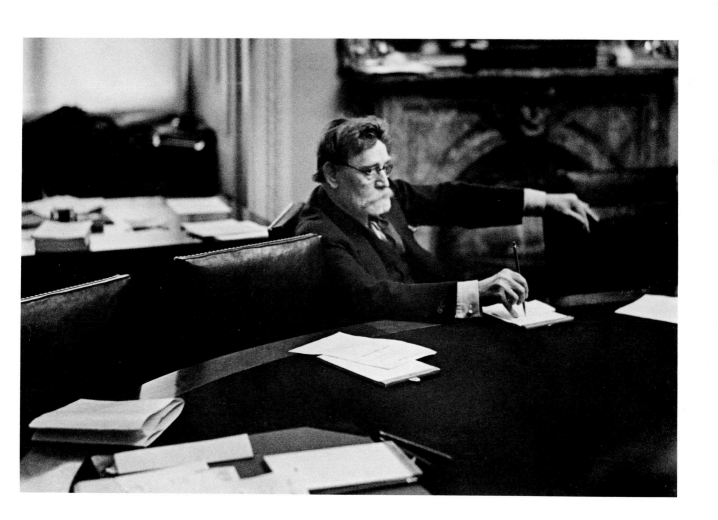

29

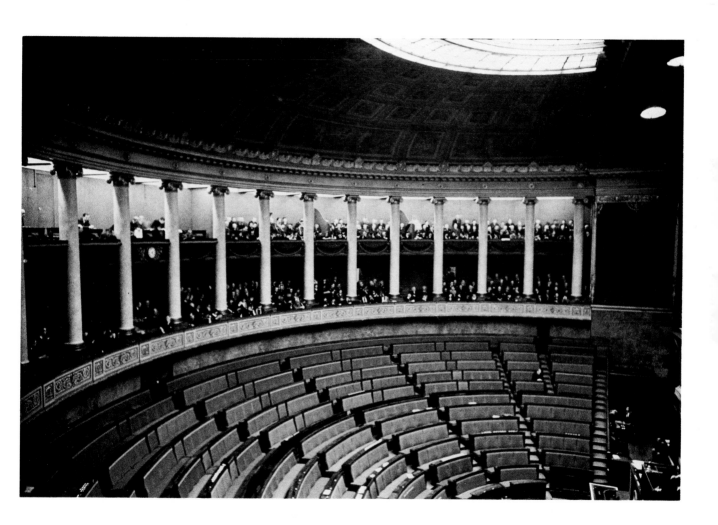

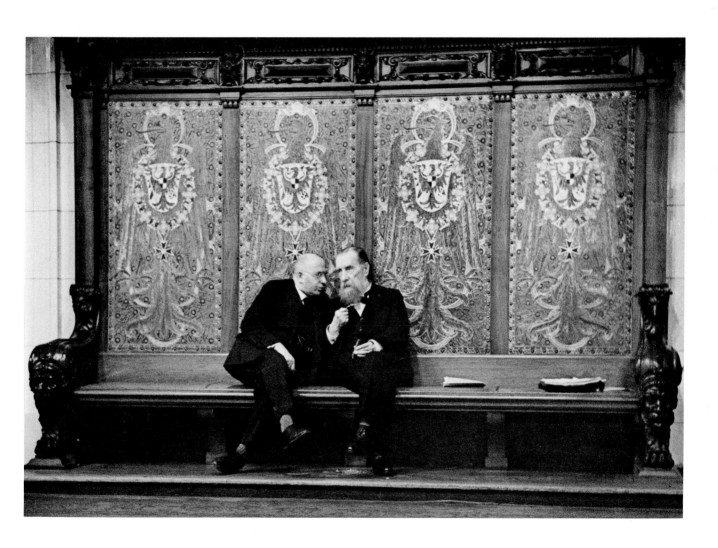

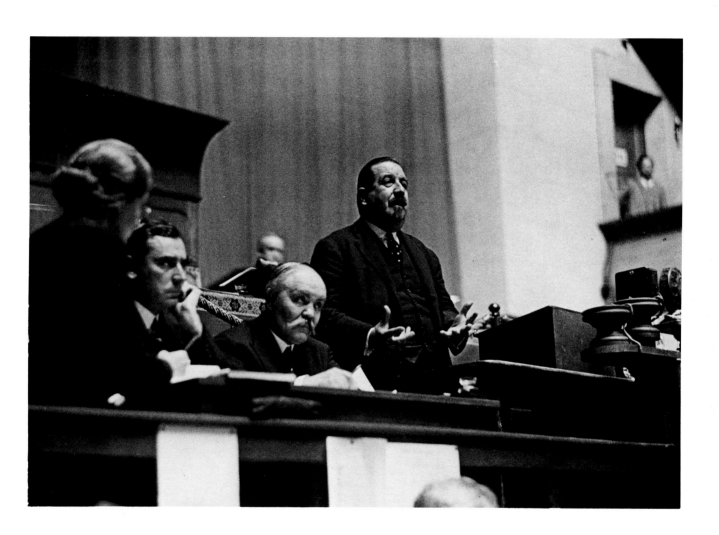

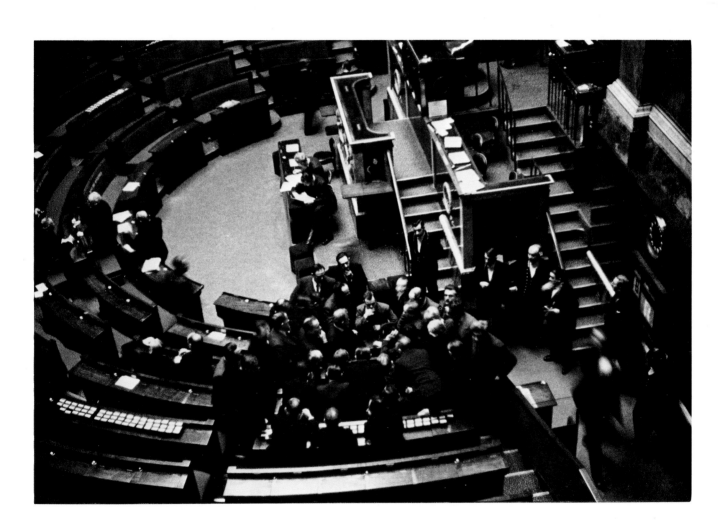

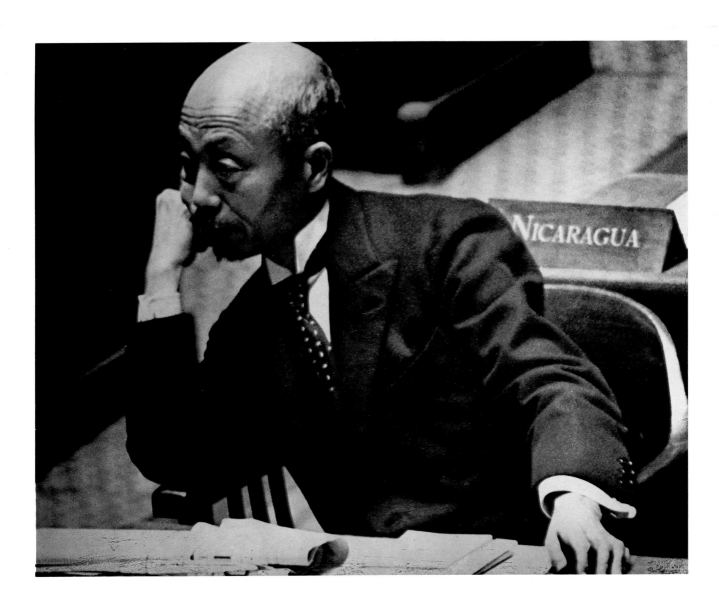

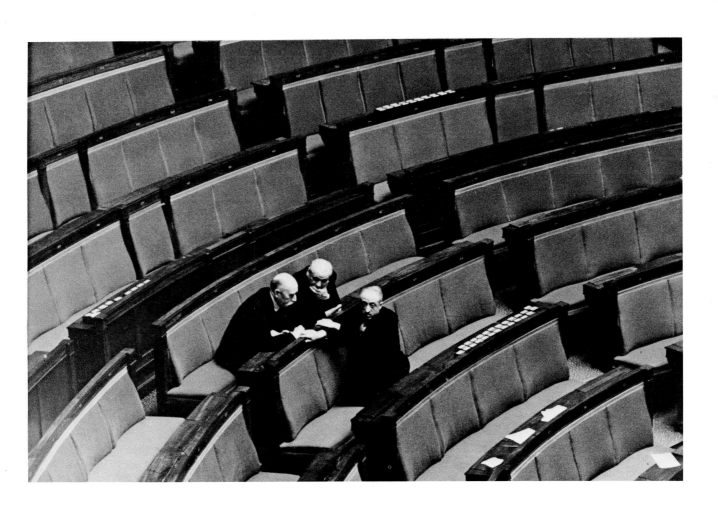

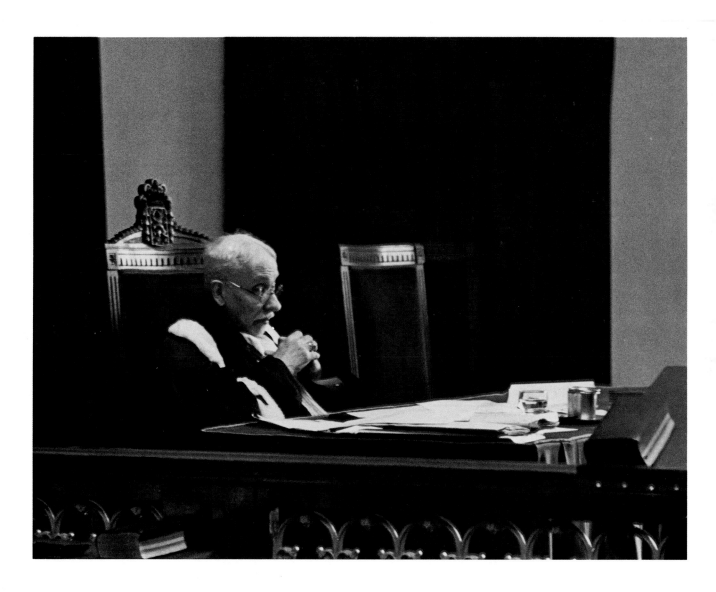

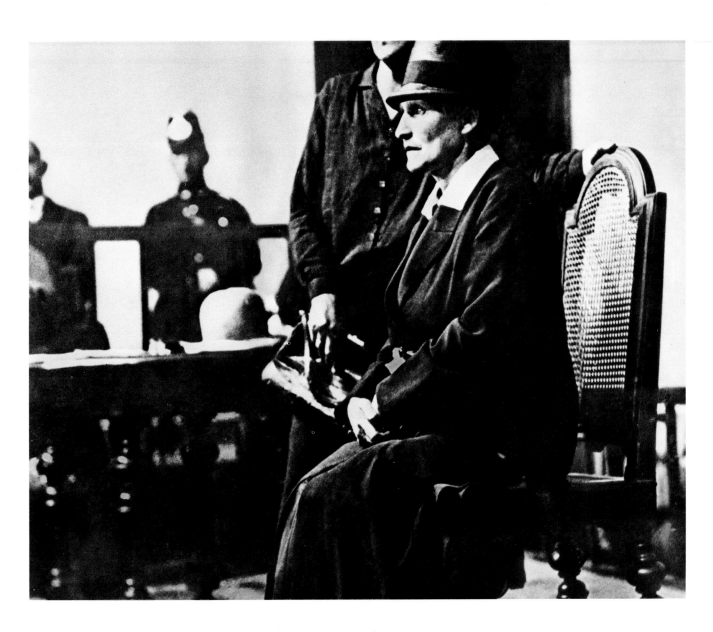

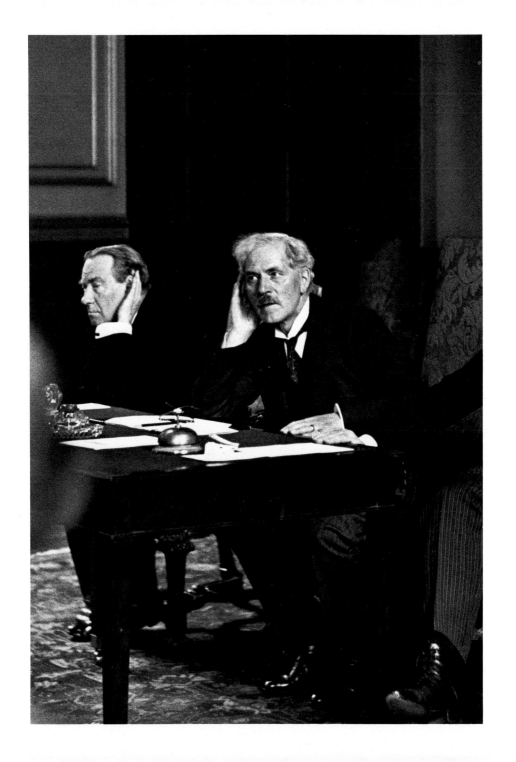

47

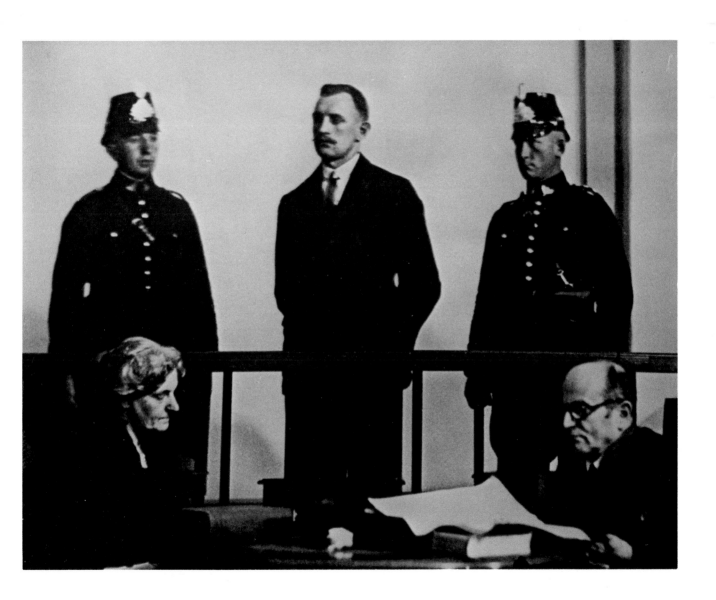

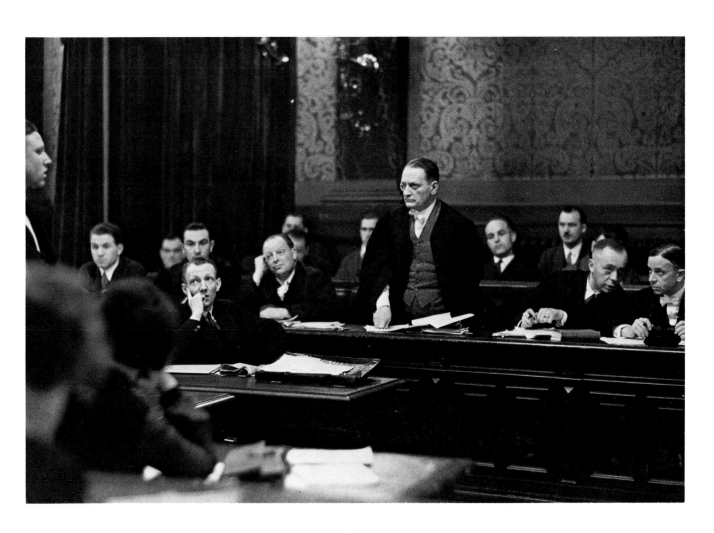

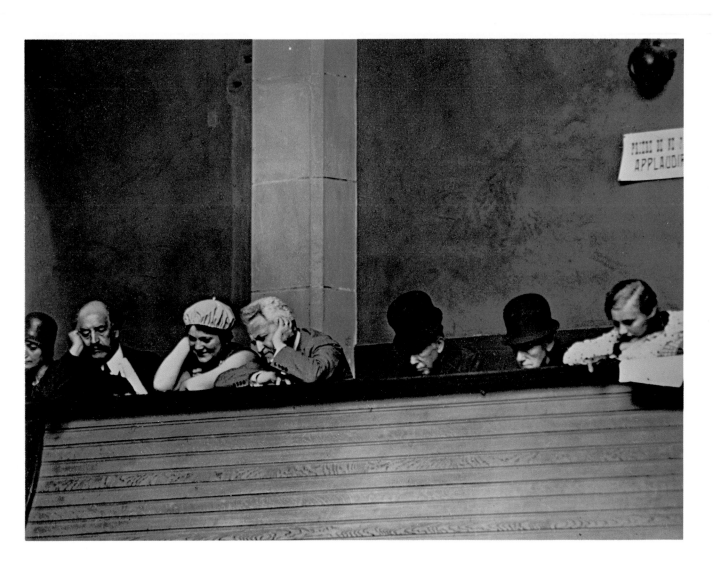

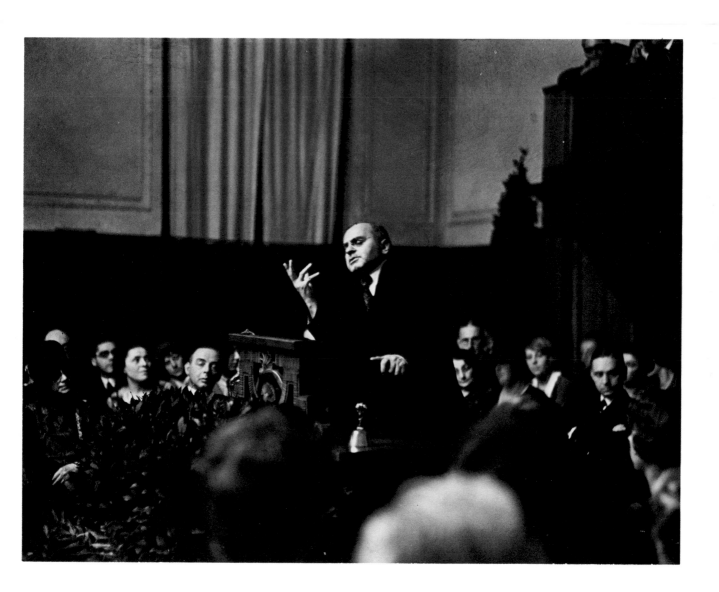

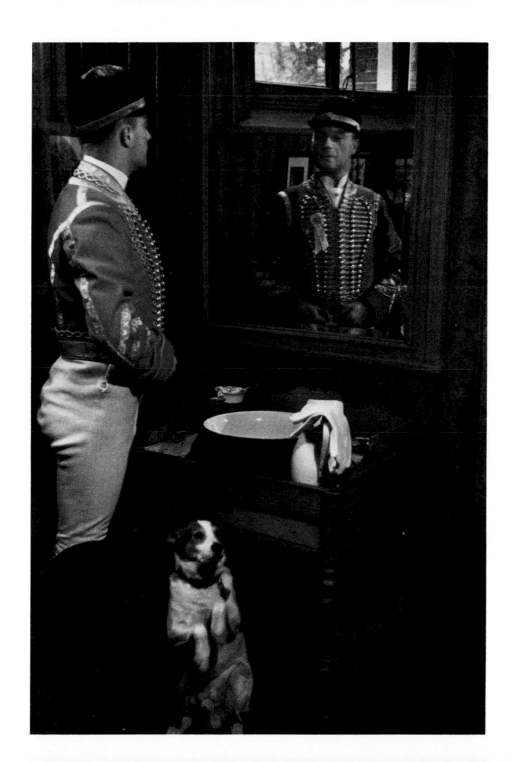

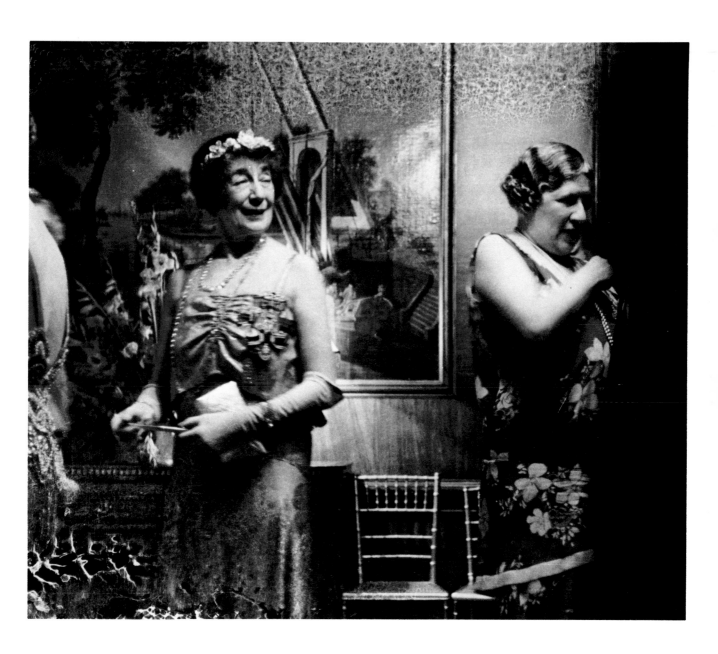

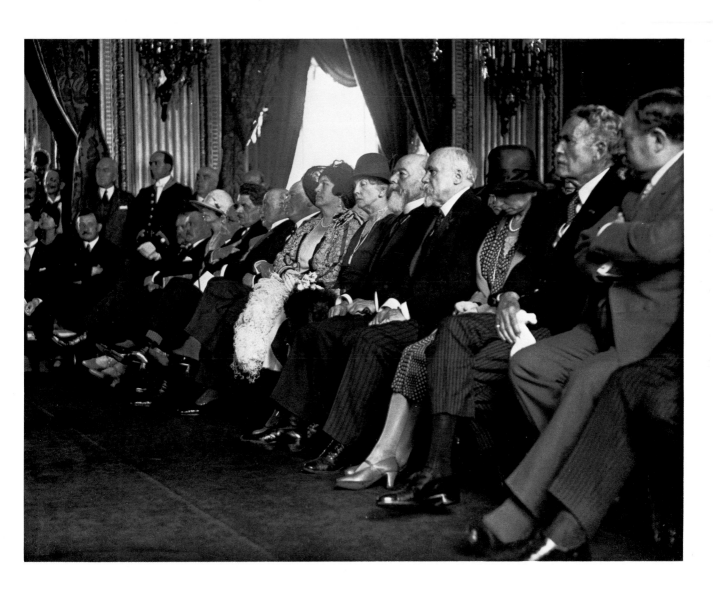

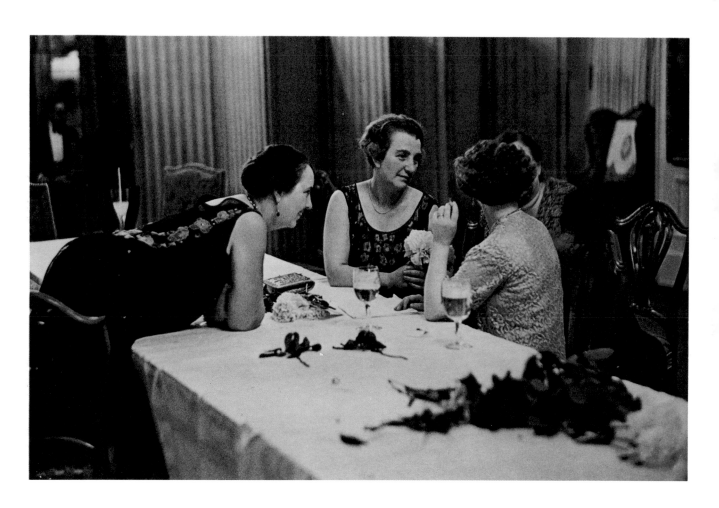

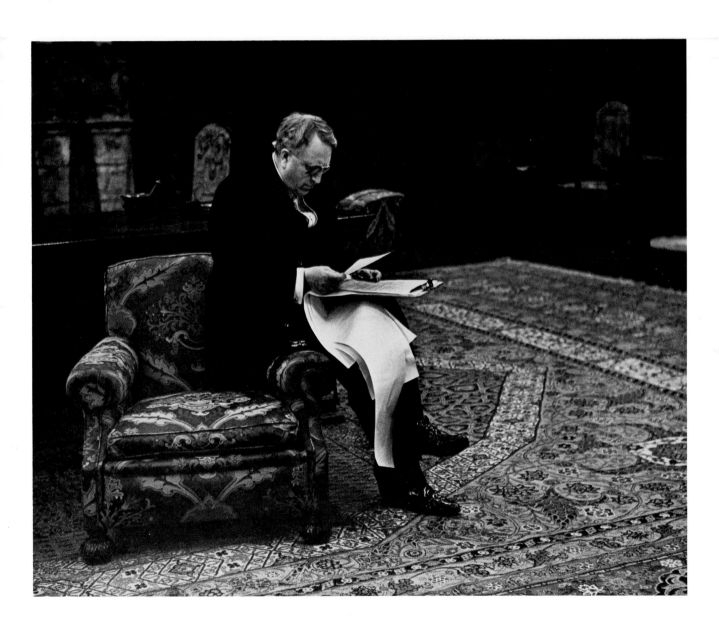

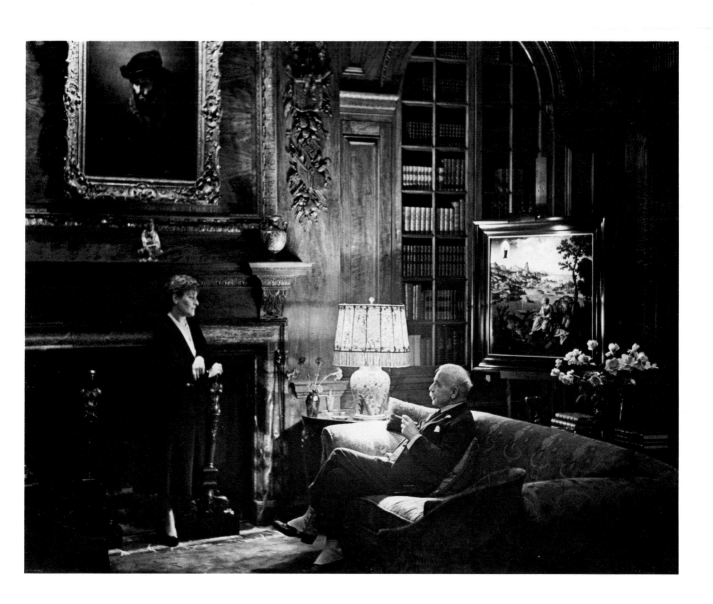

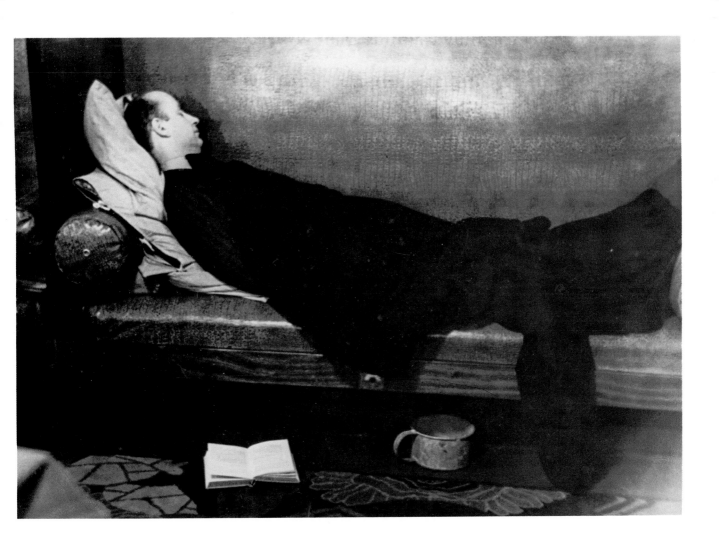

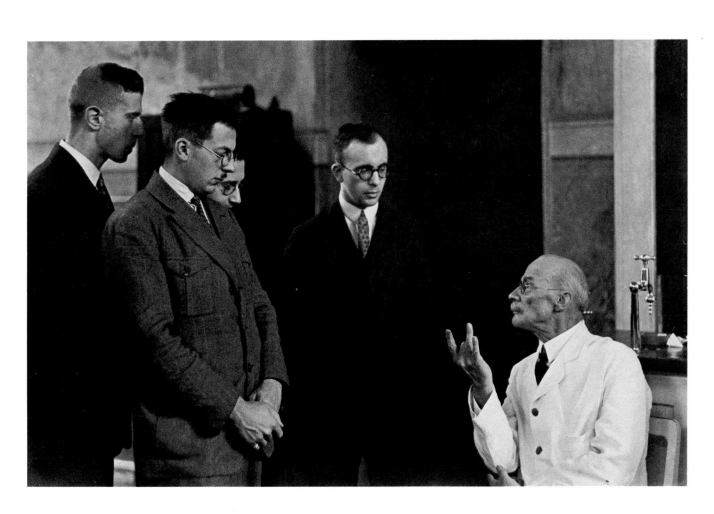

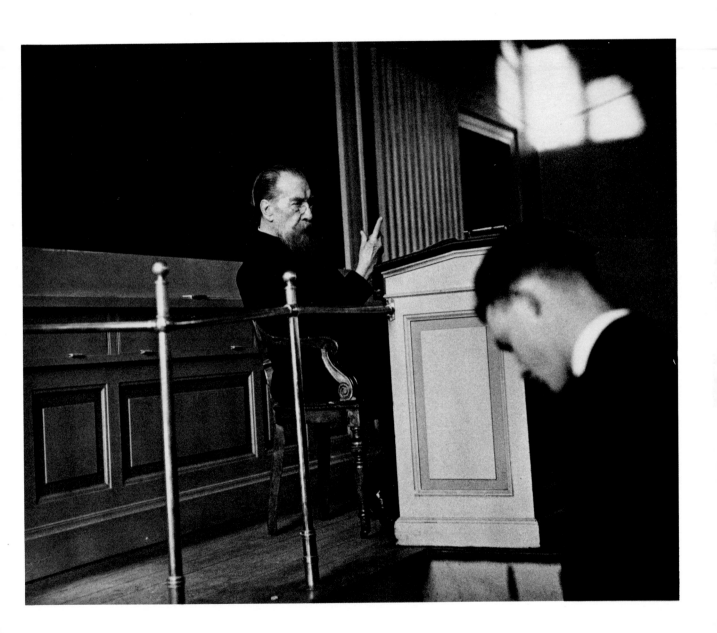

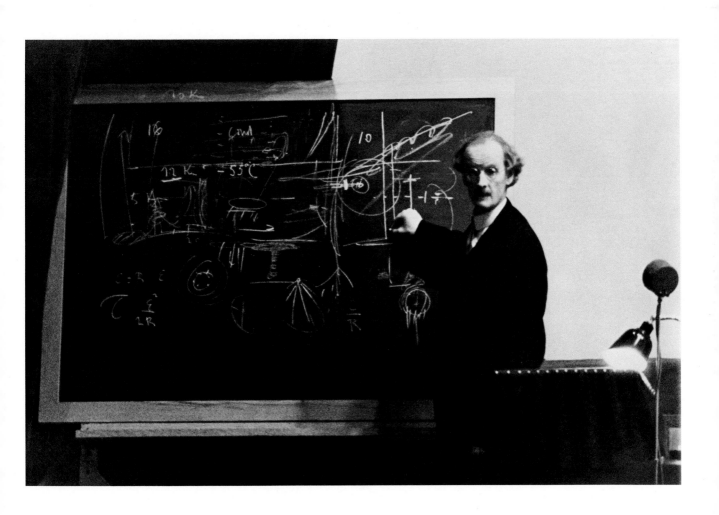

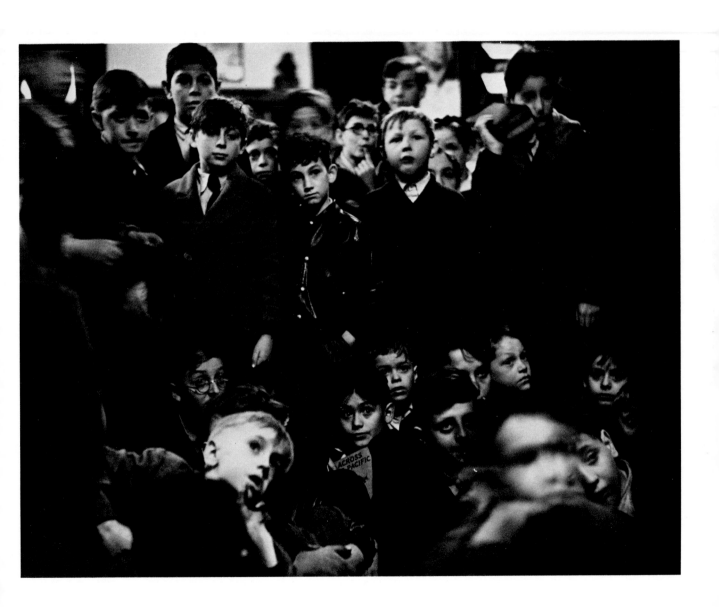

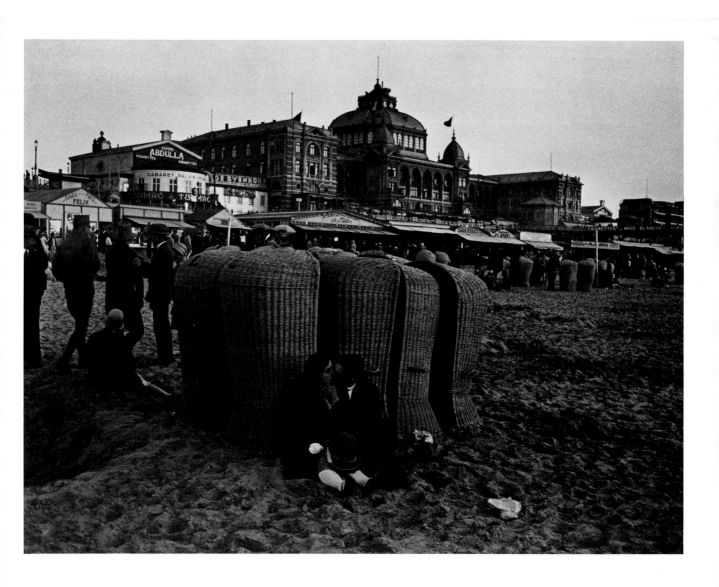

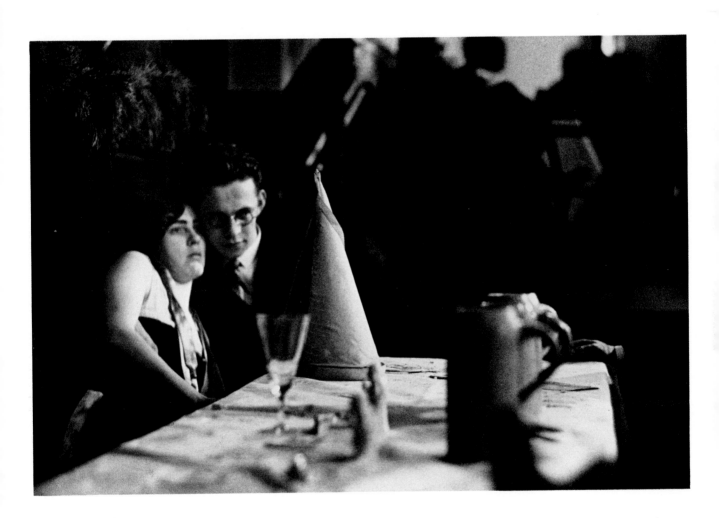

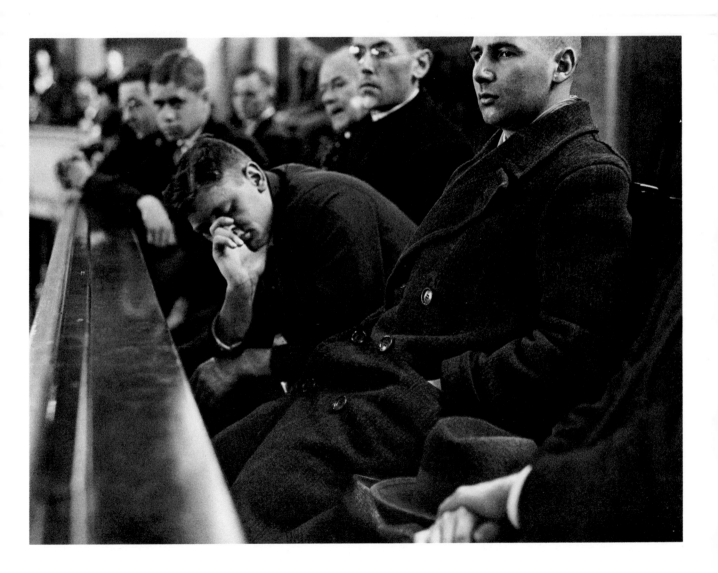

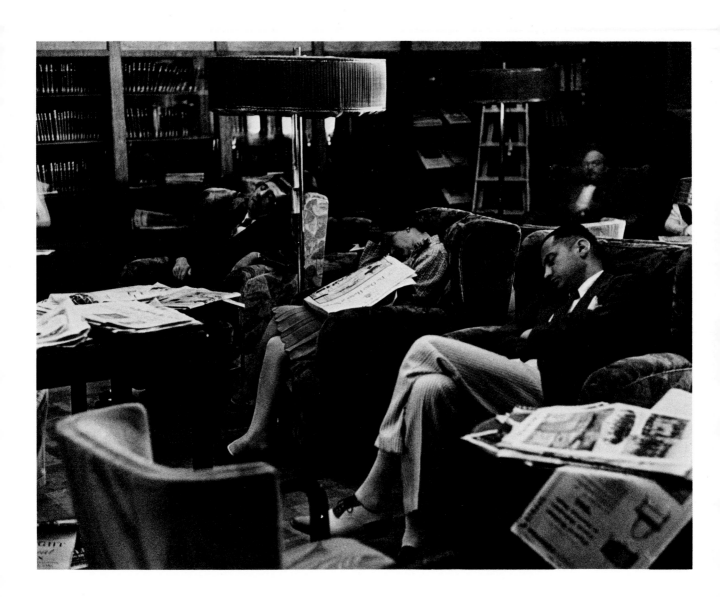

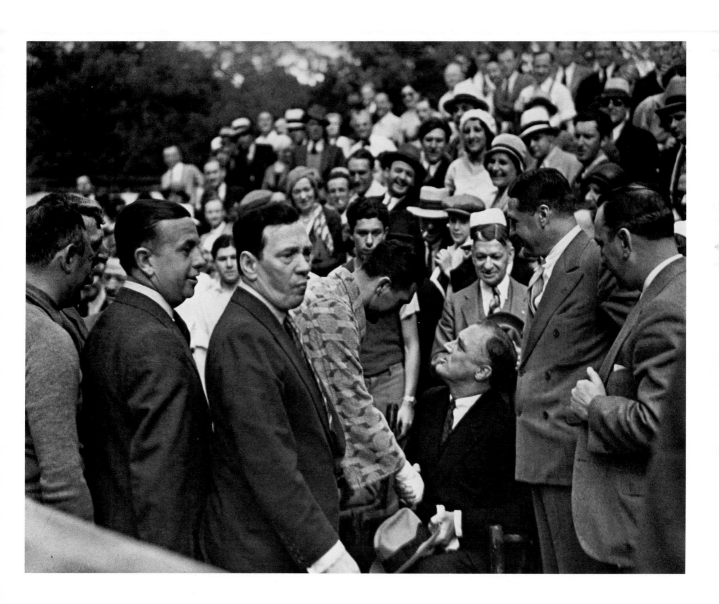

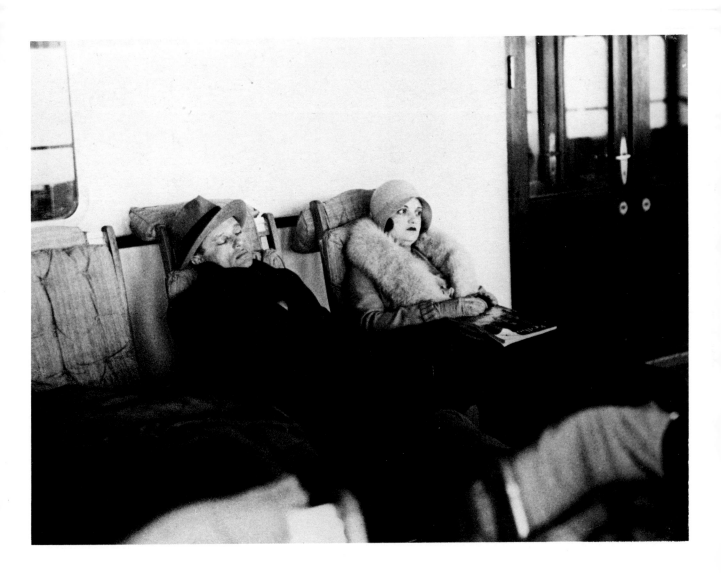

PHOTOGRAPHS

BRIEF CHRONOLOGY

1886. Born April 28 in Berlin, Germany, the fourth child of Emil Salomon, a banker, and his wife, Therese Salomon-Schuler.

1912. Marries Maggy Schuler.

1913. Receives a law degree from Rostock University after first studying zoology and then engineering; his first son, Otto Erich (aka Peter Hunter), is born.

1914–18. After being taken prisoner at the Battle of the Marne, he spends four years in POW camps in France, serving as an interpreter.

1920. Returns to Berlin; a second son, Dirk Franz Emil, is born.

1921–25. Works first on the Berlin stock exchange, then as a partner in a piano factory; starts his own car-rental business.

1925. After the failure of his own entrepreneurial ventures, he is employed in the promotion department of the Ullstein publishing house.

1927. Uses a camera for the first time.

1928. Convinces the *Berliner Illustrirte Zeitung* to let him cover a murder trial. Although photography in the courtroom is forbidden, he hides his camera in a bowler hat and returns with a scoop for the paper. Later that year, he takes his first pictures of international conferences at Lugano, Geneva, and Paris.

1929. First of many trips to London; his work is published in the *Graphic,* whose editor coins the term "candid camera" to describe his technique.

1930. Spends nine months in the United States at the bidding of *Fortune.* Photographs Marlene Dietrich and William Randolph Hearst's San Simeon estate.

1931. Publishes *Famous Contemporaries in Unguarded Moments.*

1932. Flees Nazi Germany and makes his home at the Hague, Netherlands.

1935. Works in England, the Netherlands, France, and Switzerland.

1938. Last visit to England; he begins to concentrate on Dutch political and social life.

1940. Germany occupies the Netherlands; Salomon and other Jews living in occupied lands are persecuted.

1943. Imprisoned at Scheveningen and then deported to Theresienstadt in Czechoslovakia.

1944. Dies at Auschwitz.

MAJOR EXHIBITIONS

1935. Royal Photographic Society, London.

1937. Ilford Galleries, London.

1956. Photokina, Cologne; Rathaus (town hall), Berlin-Schöneberg.

1957. Museum für Kunst und Gewerbe, Hamburg; Landesgewerbemuseum, Stuttgart; Royal Photographic Society, London; Prentenkabinet, Rijksuniversiteit, Leyden, Netherlands.

1958. George Eastman House, Rochester, New York; Time & Life Building, New York; Library of Congress, Washington, D.C.

1959. University of Miami, Coral Gables, Florida.

1963. Represented in "Great Photographers of This Century," Photokina, Cologne.

1964. Kiekeboe Club, Amsterdam.

1969. "The Portrait," Municipal Museum, the Hague.

1971. German Society for Photography, Cologne; "Sander—Salomon," Urania, Berlin.

1973. Kunstgewerbemuseum, Zurich.

1974. Fotografiska Museet, Stockholm.

1976. La Photo Galerie, Paris; Wittrock Gallery, Düsseldorf.

1977. Documenta, Kassel; Bonn, Tübingen, Zurich.

1978. Landesbildstelle, Berlin.

SELECTED BIBLIOGRAPHY

BOOKS

Berühmte Zeitgenossen in unbewachten Augenblicken, J. Engelhorns Nachf., Stuttgart, 1931.

Portrait of an Age, Macmillan, London, New York, 1966. Editor, Peter Hunter (Salomon).

"Erich Salomon," *Photo-Classics III,* Photo-Graphic Editions, London, 1972. (Portfolio of ten pictures.) By Helmut Gernsheim.

ARTICLES ABOUT ERICH SALOMON

Bennett, Edna, "History of Photography in Germany," *U.S. Camera and Travel,* November 1964.

Boker, Annemarie, *Erich Salomon Bild der Zeit,* Stuttgart, March 1972.

Bourde, Yves, "Salomon a créé le reportage indiscret," *Photo,* Paris, April 1972.

"The Camera and the Conference," *British Journal of Photography,* London, July 5, 1935.

Campen, Peter van, "Dr. Erich Salomon,"*Der Spiegel,* Wageningen, June 20, 1953.

"Candid Photography," *The Graphic,* London, November 11, 1930.

Capa, Cornell, "The Concerned Photographer," *Infinity,* New York, October 1967. *Creative Camera,* May 1968.

Deschin, Jacob, "Pioneering Candid Photographer," *The New York Times,* September 10, 1967.

"Dr. Erich Salomon—Houdini of Photography," *Photography,* London, September 1935.

Faber, John, "Erich Salomon," *The National Press Photographer,* Baltimore, November 1959.

"The First Candid Camera," *The Camera,* Life Library of Photography, New York, 1960.

Gasser, Manuel, "1929–1939: Ein Jahrzehnt im Spiegel seiner Photographen," *Du,* Zurich, July 1968.

Gernsheim, Helmut and Alison, "Fotografins historia," *Forum,* Stockholm, 1965.

Gidal, Tim, *Deutschland—Beginn des modernen Photojournalismus,* C. J. Bucher, Lucerne, 1972.

Gruber, L. Fritz, *Fame: Famous Portraits of Famous People by Famous Photographers,* The Focal Press, London, 1960.

Hens, J. J., "Dr. Erich Salomon," *Foto,* Holland, April 1957.

Hicks, Wilson, *Words and Pictures: An Introduction to Photojournalism,* Harper and Row, New York, 1952.

Hunter, Peter, "Dr. Erich Salomon: Father of Modern Photojournalism," *Camera 35,* New York, 1958.

Infinity, New York, January 1959.

Lohse, Bernd, "The Legendary Twenties," *Camera,* Lucerne, April 1967.

Newhall, Beaumont and Nancy, "Erich Salomon," *Masters of Photography,* George Braziller, New York, 1958.

Photojournalism, Life Library of Photography, New York, 1971.

Sahl, Hans, "The Photographer as Reporter, an Interview with Dr. Erich Salomon," *Gebrauchsgraphik,* Berlin, July 1931.

Weiss, Margaret, "Erich Salomon: Candid Historian," *Saturday Review,* New York, September 9, 1967.

White, Minor, "The Unguarded Moment," *Aperture,* New York, 1958.

Erich Salomon was a frequent contributor to the pictorial weeklies that proliferated in Europe and the United States between the two wars. His photographs can be found in: *Berliner Illustrirte Zeitung,* Berlin, 1928–1932; *Münchner Illustrierte Presse,* Munich, 1929–1932; *The Graphic,* London, May 1929–September 1931; *Daily Telegraph,* London, August 1935–February 1938; *l'Illustration,* Paris, October 1928–March 1938; *Life,* November 22 and 29, 1937, December 27, 1937, February 14, 1938, January 2, 1939.